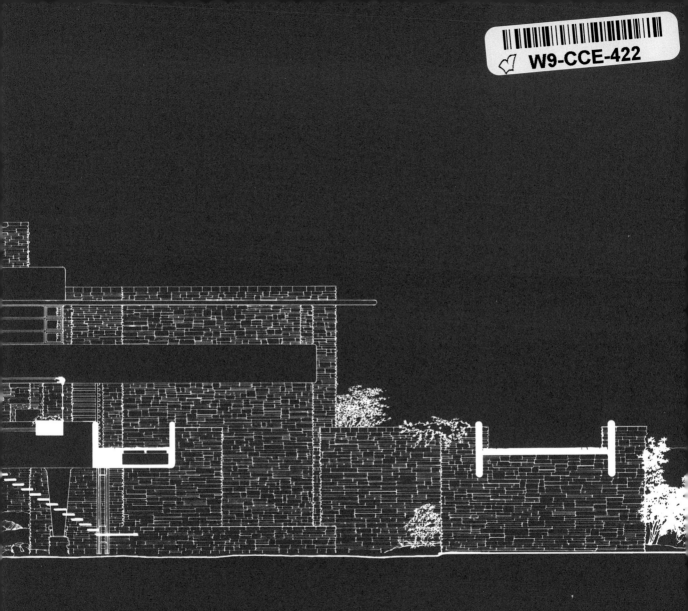

FALLINGWATER

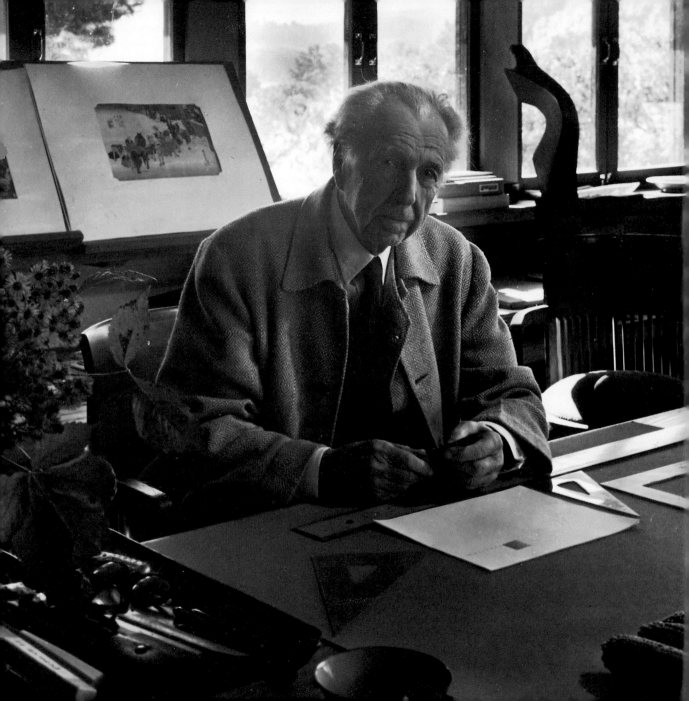

fallingwater

FRANK LLOYD WRIGHT'S ROMANCE WITH NATURE

BY LYNDA S. WAGGONER

FOREWORD BY THOMAS M. SCHMIDT

FALLINGWATER, WESTERN PENNSYLVANIA CONSERVANCY, IN ASSOCIATION WITH UNIVERSE PUBLISHING

Dedicated to the memory of my son, Thom.

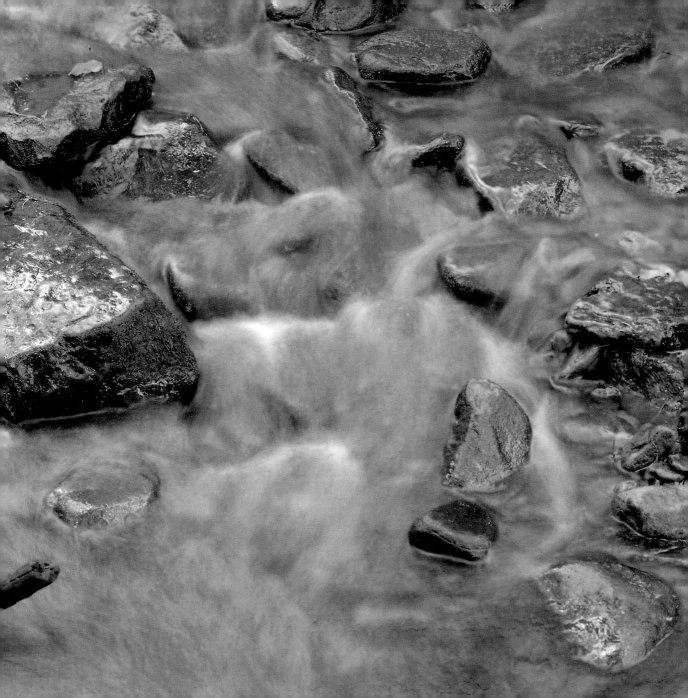

First published in the United States of America in 1996 by
UNIVERSE PUBLISHING
A Division of Rizzoli International Publications, Inc.
300 Park Avenue South
New York, NY 10010

98 99/10 9 8 7 6 5 4 3

Library of Congress Catalog Card Number: 96-60690

Printed in Singapore

Front cover: Fallingwater, Southwest elevation, Fall (detail)
Back cover: Stream, Western Pennsylvania (detail)
Endpapers: Main house, East/West section
Title page: Frank Lloyd Wright in his private study
and bedroom at Taliesin, Spring Green, Wisconsin (detail)
Frontispiece: Rushing stream, Powdermill Nature Preserve
Contents page: Western Pennsylvania woods

DESIGN BY YOLANDA CUOMO AND DOMITILLA SARTOGO

CONTENTS

FOREWORD

In 1934, when he was a twenty-five-year-old apprentice of Frank Lloyd Wright's, Edgar Kaufmann, jr. introduced the great architect to his father, the owner of a Pittsburgh department store. The commission that resulted was for a weekend house in a forested Appalachian hollow where the Kaufmann family loved to picnic near a waterfall. They expected that Mr. Wright would build the house facing the cascade. They were astounded when he proposed to raise the house over the falls, but the architect's original conception was adopted almost without change. The resulting structure is fitted onto a narrow cliff ledge, with walls of rough local sandstone and terraces of reinforced concrete that project dramatically over the stream and falls.

Completed with guest and service wing in 1939, Fallingwater served as a country place for the Kaufmann family from 1937 until 1963. Edgar Kaufmann, jr. wrote: "It has served well as a house, yet has always been more than that, a work of art beyond any ordinary measure of excellence. Itself an ever-flowing source of exhilaration, it is set on the waterfall of Bear Run, spouting nature's endless energy and grace. House and site together form the very image of man's desire to be at one with nature, equal and wedded to nature."

Upon its completion, Fallingwater became instantly famous. It appeared on the cover of *Time* and was the subject of a show at the Museum of Modern Art. Its fame had increased fifty years later

The Kaufmann family, 1940s
Left: Edgar Kaufmann inspecting the
contruction of his house (detail), 1936

when *The New York Times* architecture critic Paul Goldberger wrote: "This is a house that summed up the 20th century and then thrust it forward still further. Within this remarkable building Frank Lloyd Wright recapitulated themes that had preoccupied him since his career began a half century earlier, but he did not reproduce them literally. Instead, he cast his net wider, integrating European modernism and his own love of nature and structural daring, and pulled it all together into a brilliantly resolved totality. Fallingwater is Wright's greatest essay in horizontal space; it is his most powerful piece of structural drama; it is his most sublime integration of man and nature."

The masonry walls of sandstone quarried on the site were laid to resemble the natural cliffs bordering Bear Run. Frank Lloyd Wright often abstracted a visual element of the landscape this way. Similar stonework is part of Taliesin, his home in Wisconsin, begun in 1911. The reinforced concrete, of which Fallingwater's terraces and canopies are formed, contrasts with the static, immovable stone walls. The architect treated the concrete like the water in Bear Run, as a neutral, plastic element. This material was stretched to the limits of its tolerances, especially in the thrusting terraces and the eight-foot-wide canopy over the walkway to the guest house.

Fallingwater changes as you walk around it—cascading as viewed from the east, calm and serene from the south, thrusting and dynamic from below the falls on the west. Neil Levine, Professor of Fine Arts at Harvard University, points out that Fallingwater can be seen as a piece of kinetic sculpture representing water as a flowing, falling liquid. Many other details and leit-motiv reinforce the dynamic quality of this wonderful place. In 1996 Levine wrote: "Always all things at once, it remains as magical, as hallucinatory and as ethereal as a cascade of white water or an early morning mist."

Edgar and Liliane Kaufmann on the terrace of the main bedroom, 1940s

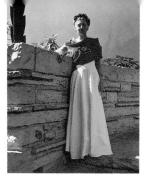

In 1963, Edgar Kaufmann, jr. gave Fallingwater away. The usual recipients—governments, universities, museums—were bypassed in favor of a regional nature conservation agency, the not-for-profit Western Pennsylvania Conservancy. Mr. Kaufmann believed that the Conservancy would be a better guardian of Fallingwater's future because it was "devoted to the salutary and encompassing values of human life in touch with nature."

Most house museums struggle to attract a few thousand visitors a year. Fallingwater draws to its remote glen over 130,000 people annually, and many have to be turned away to protect the house and site from overcrowding. Why does Fallingwater speak so powerfully to ordinary people? One reason is that they can take home from this wealthy man's house rich insights about how everyone can live with art, architecture, and good design. Even more fundamentally, as the text and pictures in this book illustrate, Frank Lloyd Wright's masterwork is a metaphor for how we can live vitally with nature.

Wright's ideals and principles are as useful to people who seek a balance between nature and modern living today, as they were to his clients sixty years ago. We hope this selection of photographs illustrating some of the many ways Wright incorporated nature into Fallingwater, as well as text by Wright and those who influenced him, will inspire others to protect nature and to look to it as a source for inspiration and refreshment.

——Thomas M. Schmidt, Director, Fallingwater

Liliane Kaufmann at Fallingwater, late 1940s

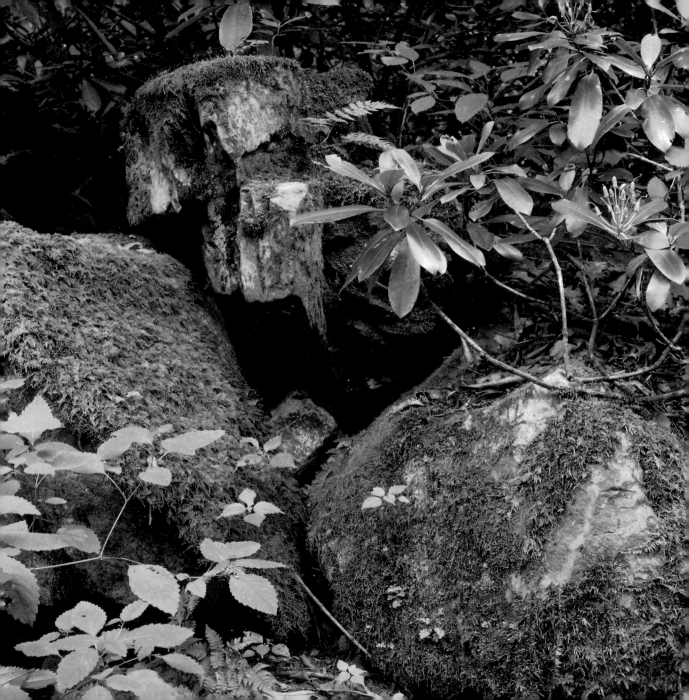

INTRODUCTION

Few works of architecture have succeeded more in touching our hearts and minds than Frank Lloyd Wright's Fallingwater. Located in the Allegheny mountains of southwestern Pennsylvania and designed for the weekend use of a Pittsburgh family of three, it continues to fascinate us sixty years after its construction. Unlike most historic homes, which celebrate an important person or event, Fallingwater celebrates an idea: that technology, imagination, and nature when brought together in the service of man can result in great art. To understand the appeal of Fallingwater, we must begin with the land. To be sure, the site cannot be improved upon: a pristine stream in a secluded glen, towering hemlocks and oaks, masses of rhododendron, rugged outcroppings of sandstone, and water rushing over a rock ledge onto the stream floor twenty feet below. If it were in Japan, these features alone would merit a shrine where priests go to commune with the gods that dwell in such places. But here, Frank Lloyd Wright and Edgar Kaufmann chose to build not a shrine to access the spirits of the waterfall, but a house for a family who loved nature.

Fallingwater was created as a place for restoration in nature, a romantic notion that historically underlies the construction of nearly every weekend retreat—from Marie Antoinette's *Le Hameau,* her picturesque notion of a peasant's woodland cottage on the grounds of Versailles, to the great camps of the Adirondacks or Thoreau's humble shelter on Walden Pond. In nature the Kaufmanns

Allegheny National Forest
Left: Rhododendron and mossy rocks, Western Pennsylvania

sought the peace and balance that was depleted by the busy pace of their weekday lives in the city. By commissioning Frank Lloyd Wright as their architect, they were looking for a more creative solution to their needs.

For the Kaufmanns, Fallingwater was to be the consummate romantic experience. Edgar Kaufmann, jr. wrote: "In Fallingwater Wright captured the perfect essence of our desire to live with nature, to dwell in a forested place and be at home in the natural world." Designed to fit the routines of a family that enjoyed contemplative time indoors, reading and good conversation, as well as vigorous exercise out of doors, its asymmetrical open plan was ideal for their informal weekend life. But perhaps the best testament to the ultimate success of Fallingwater came from Liliane Kaufmann in a note to Frank Lloyd Wright: "Living in a house built by you has been my one education."

Frank Lloyd Wright's love affair with the natural world began when he was a child growing up on land settled by his Welsh ancestors near the Wisconsin River. There nature was spread out for the hungry young Wright like a feast to be devoured. Wooded hills surrounded open fields, which were cut through by streams that coursed off into a broad river valley edged with rock bluffs worn away by the forces of water and weather.

As a boy of eleven working on his family's farm, Wright gained an experiential understanding of nature's forms and processes. In his autobiography he recalls learning about the woods while searching for lost cows and discovering the plasticity of mud oozing between his toes as he walked barefoot in the garden. He studied light, noting its different characteristics at dawn and at dusk.

Allegheny National Forest

He observed the blue of night shadows and the way in which the sun filtered through the leaves of trees, dappling light on the ground beneath. He also recognized nature's duality, its unrestrained, seemingly chaotic power in contrast to its subtle, ordered beauty. And he came to understand that it is the dichotomy in nature which accounts for its richness.

Wright's youthful observations were confirmed and further developed as he read the works of Whitman, Emerson, Ruskin, and Thoreau. From Whitman, Wright formed the conviction that a close relationship with the landscape was an American birthright. He believed his architecture, rooted in a deep understanding and appreciation of nature, would be the first truly American architecture. Emerson's assertion that the beautiful and the useful should never be separated from one another became a guiding principle for Wright. Ruskin offered confirmation of the architect's noble role as intercessor between nature and man. And like Thoreau, Wright valued the wildness of the American landscape and mourned civilization's incursions. The influence of nineteenth-century writers in addition to childhood days spent roaming his small but fertile world left an imprimatur on Wright that resonated in every building he created.

The commission for Fallingwater came to Wright in 1935 when he was sixty-eight years old. He had begun his practice in 1892 and by 1935 had designed literally hundreds of buildings and achieved an international reputation. However, by the mid-1920s, Wright's career was in decline. Architecture was changing dramatically; the lingering romance of the nineteenth century was giving way to buildings designed as "machines for living." This change, combined with a well-publicized and difficult divorce, resulted in little work for Wright. Many people assumed he was retired. He had written his

Old maple, Western Pennsylvania

autobiography, and was devoting most of his time to the Taliesin Fellowship, a school he founded on land given to him by his family in Wisconsin. But these were not fallow years, indeed it was a time during which Wright's genius matured, culminating in a new brilliance and energy that would manifest itself over and over until his death in 1959.

Unlike many architects, Wright loved designing houses. In his essay "The Natural House" he wrote that a proper house should be one that is "integral to site; integral to environment; integral to the life of the inhabitants." Houses were places to be fitted to clients, like a tailor fits a suit. Their form should be so in tune with the setting as to appear that they were growing from their site, like a tree grows from the ground. He called the style "organic architecture."

Wright recognized several principles in organic architecture. He believed that buildings should have a quality of shelter about them: "I began to see a building primarily not as a cave but a broad shelter in the open, related to vista without and vista within." When inside, one should experience a sense of protection from nature but not feel cut off from it. At Fallingwater a feeling of shelter and protection is provided by the massive stone walls at the dark northern end of the house. This is richly contrasted by the openness on the opposite side of the building where bands of windows offer vistas and sunny terraces soar out over the waterfall.

Wright also believed buildings should look as if they belong to the ground—they should have a sense of repose: "The planes parallel to the earth in buildings, do most to make the buildings belong to the ground." He recognized that the key to the Fallingwater site was the fractured rock shelf that had resulted in the creation of the waterfall. Broad and thick, it is the ground exposed. But unlike the

McConnell's Mill State Park

ground, it hangs out in space, the earth beneath it having eroded away. To most architects it would be an unbuildable site, but for Wright the waterfall ledge became the primary source of inspiration for the house. In the cantilevered building above, he used broad horizontal trays of reinforced concrete stacked one upon the other to create the three floors, which are separated only by bands of windows that recess into the interior space as if they too have been eroded by nature.

By the time he designed Fallingwater, Frank Lloyd Wright had developed a repertoire of design details and approaches to connect his buildings to nature. Large trees were treated as revered ancestors, and in deference to their exalted position, when one was in too close proximity to a building, he chose either to build around it or to incorporate it into the design rather than cut it down. Rock formations also became integral features within his buildings. At Fallingwater they rise out of the floors and meld into the walls in ways that defy any effort to separate house from site.

Wright saw in nature a harmonious order. In his buildings he sought a new unity that would speak to our desire to be reunited with nature. Fallingwater is his nature poem. As if planted by God, it grows from its site with a grace unparalleled in the history of architecture. Rarely have materials or space been handled so skillfully or with such natural ease. Rising above the waterfall, Fallingwater creates a sense of place the waterfall alone could never have achieved.

—Lynda S. Waggoner, Curator and Administrator, Fallingwater

Apple tree, Bear Run

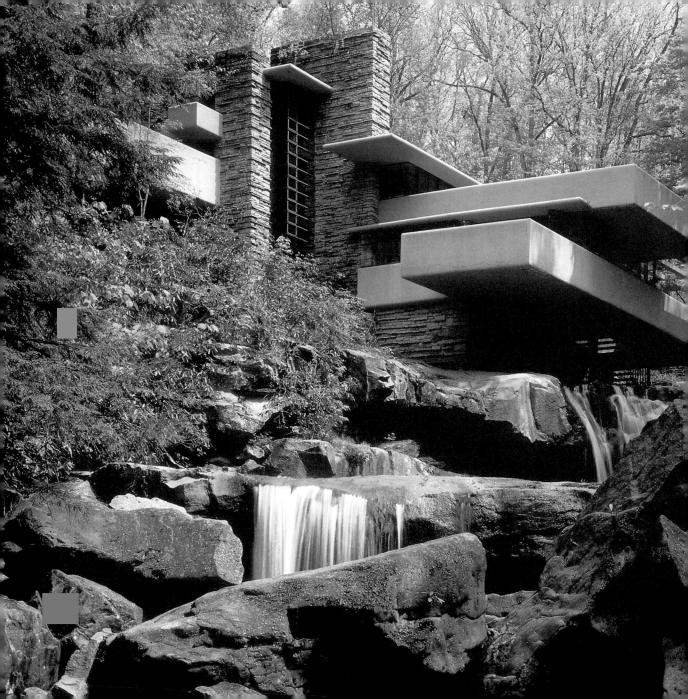

Man's works must lie in the bosom of Nature, cottages be buried in trees, or under vines and moss, like rocks, that they may not outrage the landscape. —Thoreau

Southwest elevation, Spring

The Power of human mind

had its growth in the wilderness;

much more must the love and the conception

of that beauty, whose every line

and hue we have seen to be, at the best,

a faded image of God's daily work,

and an arrested ray of some star of creation,

be given chiefly in the places which

He has gladdened by planting there

the fir tree and the pine.

—Ruskin

Muddy Creek, Western Pennsylvania

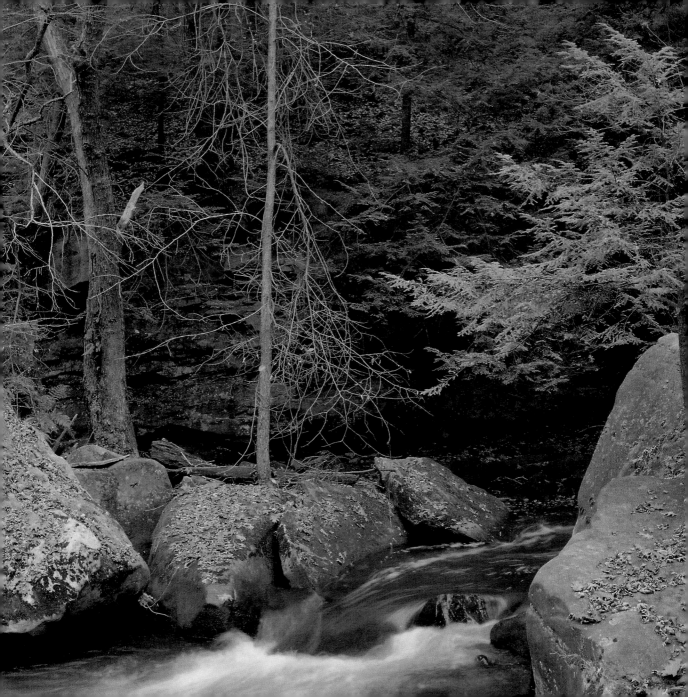

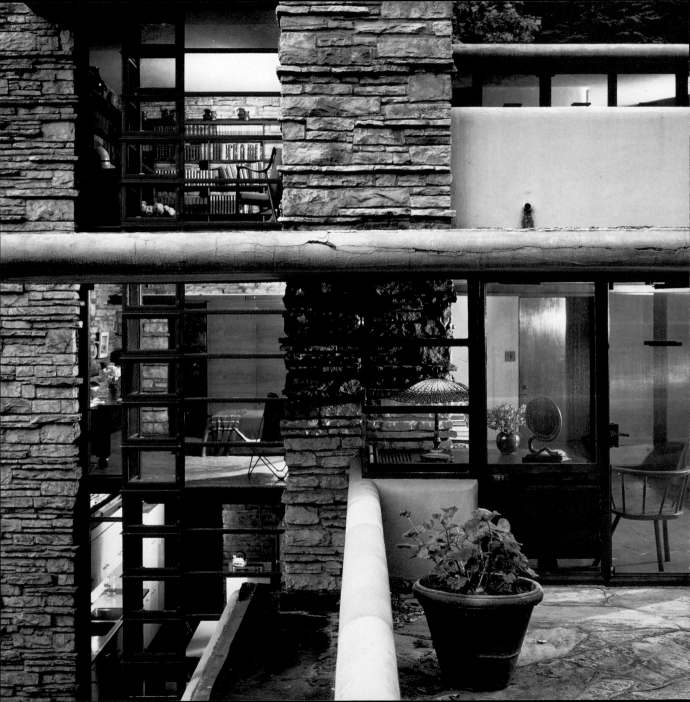

ORGANIC ARCHITECTURE

sees actuality as the intrinsic romance of human creation or sees romance

as actual in creation.... In the realm of organic architecture

human imagination must render the harsh language of structure

into becomingly humane expressions of form instead of devising inanimate

façades or rattling the bones of construction. Poetry of form is as

necessary to great architecture as foliage is to the tree,

blossoms to the plant or flesh to the body.

—Frank Lloyd Wright, 1953

Tower window, masonry chimney,
and master bedroom terrace

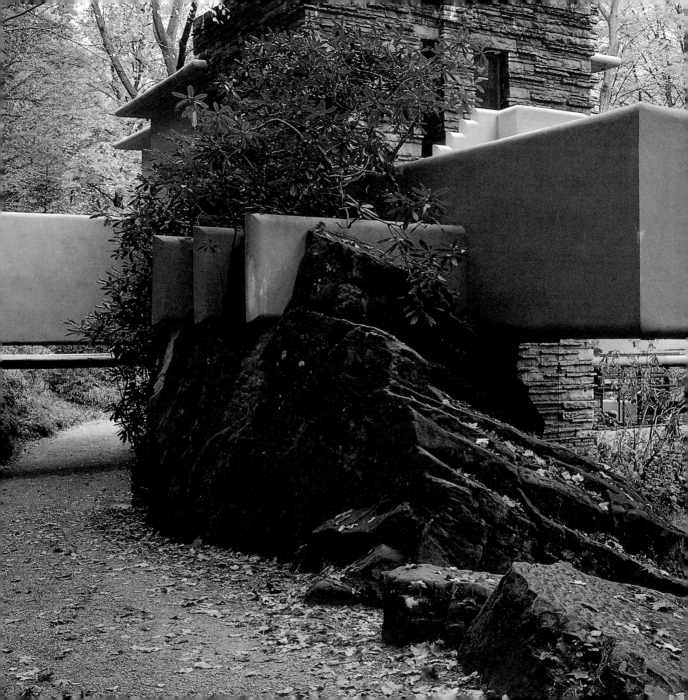

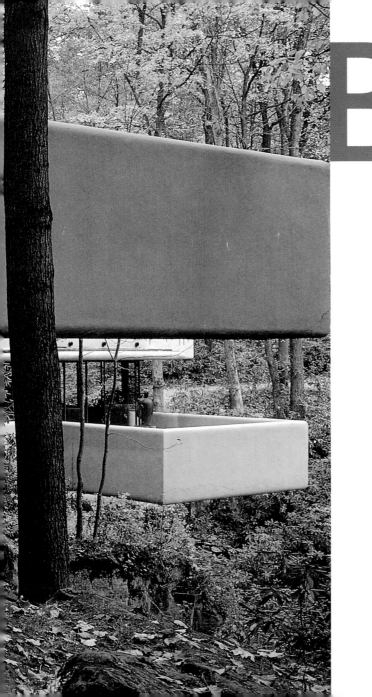

But in this land of ours,
richest on earth, in
old and new materials,
the architect must exercise
well-trained imagination
to see in each material,
either natural or compounded,
its own inherent style.
All materials may be beautiful,
their beauty depending much
or entirely upon how well they
are used by the architect.
—Frank Lloyd Wright, 1932

Edgar Kaufmann's
dressing room terrace

ow we learn what patient periods must round themselves before the rock is formed, then before the rock is broken, and the first lichen race has disintegrated the thinnest external plate into soil, and opened the door for the remote Flora, Fauna, Ceres, and Pomona, to come in.

—Emerson

Fractured sandstone rocks,
Western Pennsylvania

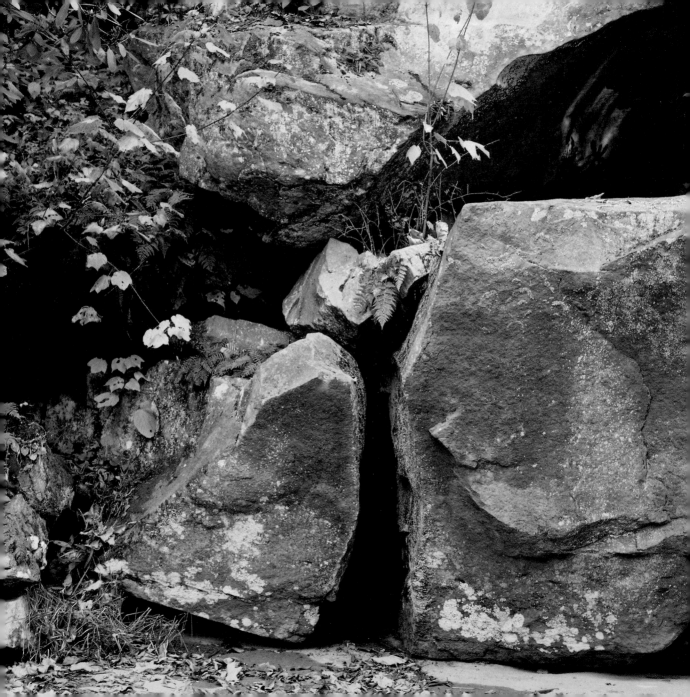

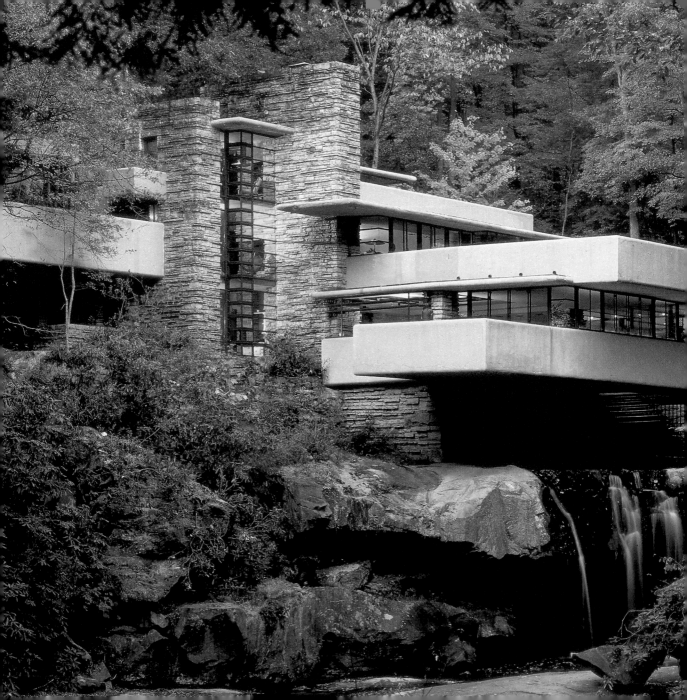

My prescription for a modern house:

first pick a good site.

Pick that one at the most difficult site—

pick a site no one wants—

but pick one that has features

making for character:

trees, individuality,

a fault of some kind in

the realtor mind.

—Frank Lloyd Wright, 1938

Southwest elevation, Fall
Following pages: Trellis, Summer

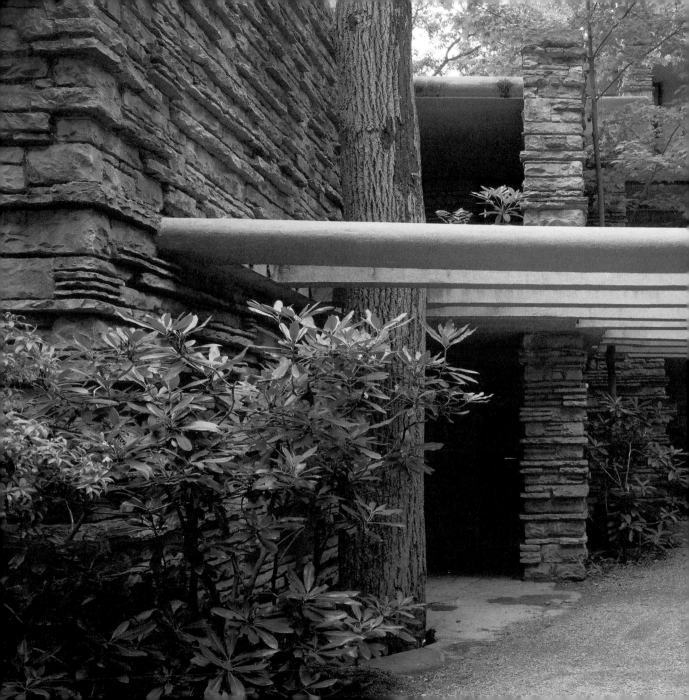

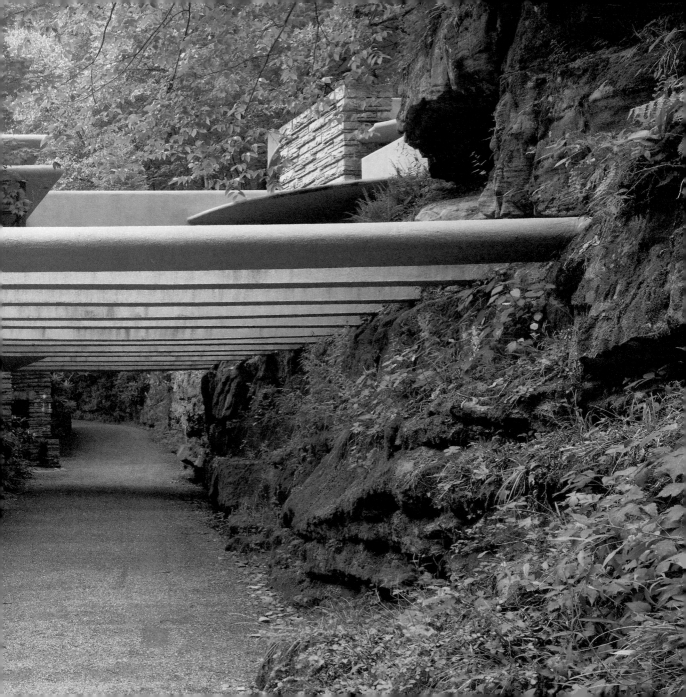

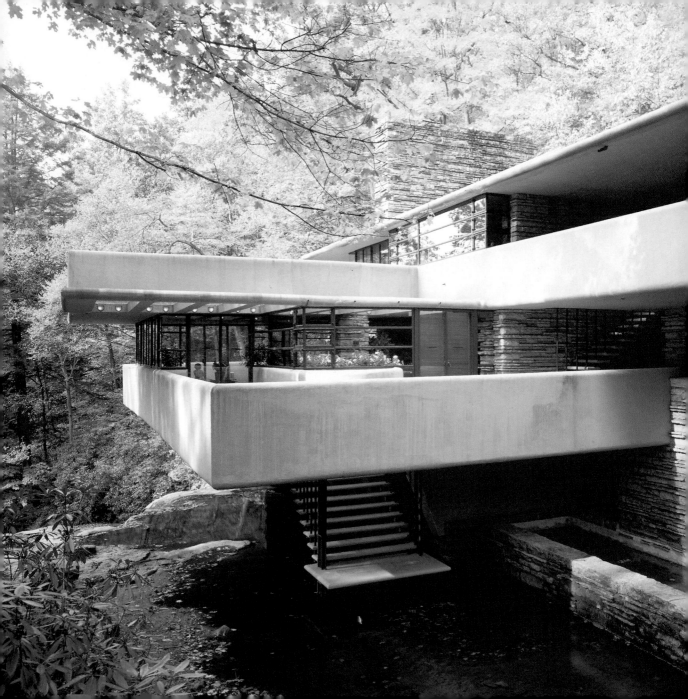

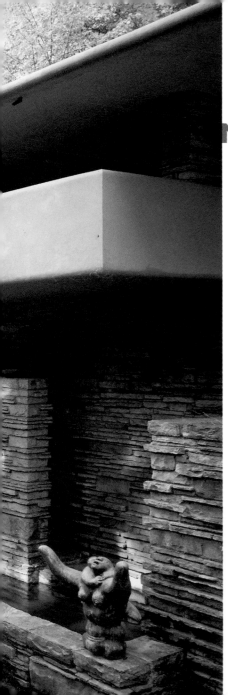

MATERIALS

The construction materials Wright
chose for Fallingwater included
sandstone, quarried on the site,
reinforced concrete, glass, and steel.
The intrinsic quality of each material is
emphasized by the manner in which it
is treated. For example, the stone is laid
up in a rough, horizontal fashion that is
reminiscent of the native sandstone
formations found in the region.
The steel is painted Cherokee red, a
color indicative of the fire-fueled steel-
making process. Even the pale ocher color
of the concrete suggests the earthen
nature of the material.

East elevation, Fall

Clients and architect

alike were aware,

without discussion, of a peculiar

blend of dynamic natural activity and an

air of repose, even of stability.

The dynamics are created by

the abrupt break in the rock strata,

which induces the

drama of water pouring freely

over the ledge.

Beyond this immediately noticed

effect, attention is drawn to the two

discrete levels of vegetation which further accent

the fault in the structure of nature.

—Edgar Kaufmann, jr.

Southwest elevation, Summer

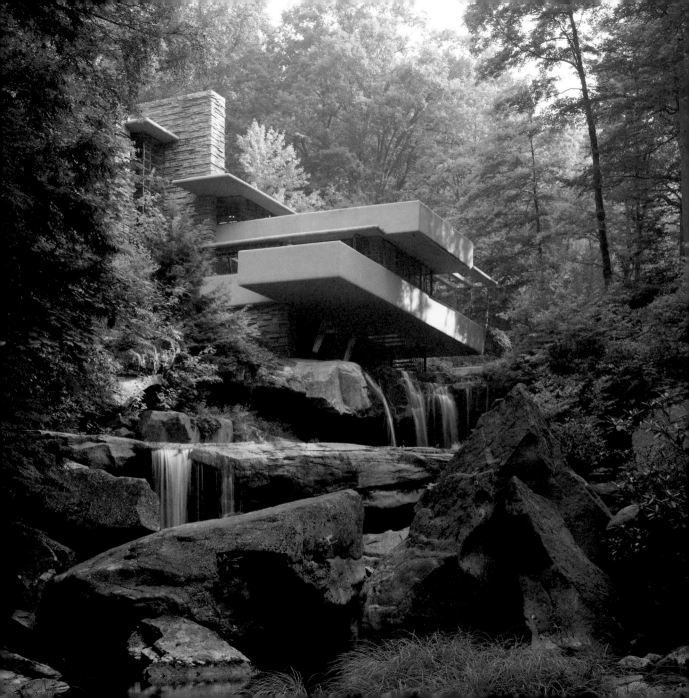

The lilies of the field,

the leaves of the trees, the insects, have style,

because they grow, develop, and

exist according to essentially logical laws.

We can spare nothing from a flower,

because, in its organization,

every part has its function and is formed

to carry out that function

in the most beautiful manner.

—Viollet-le-Duc

Narcissus, Bear Run

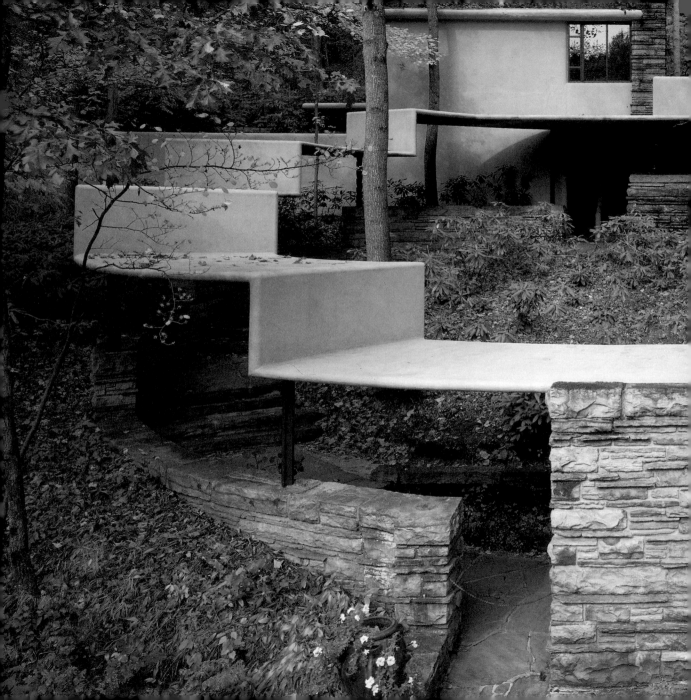

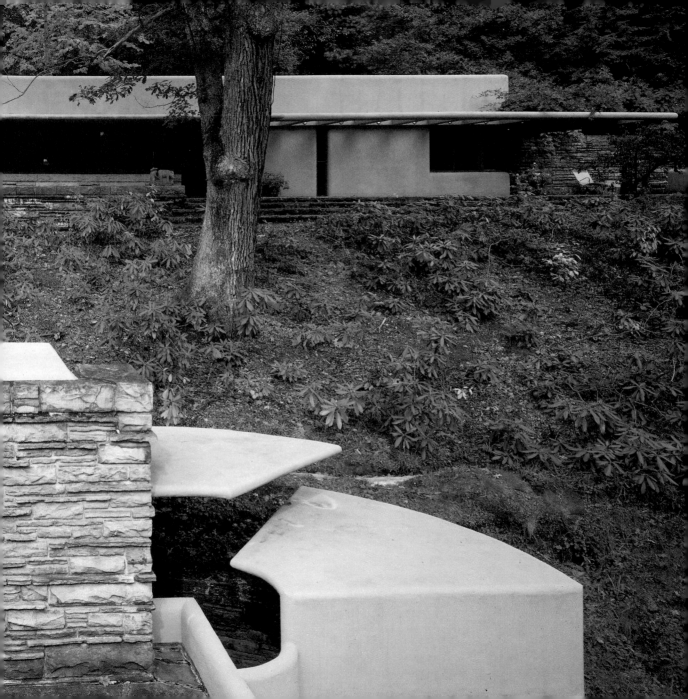

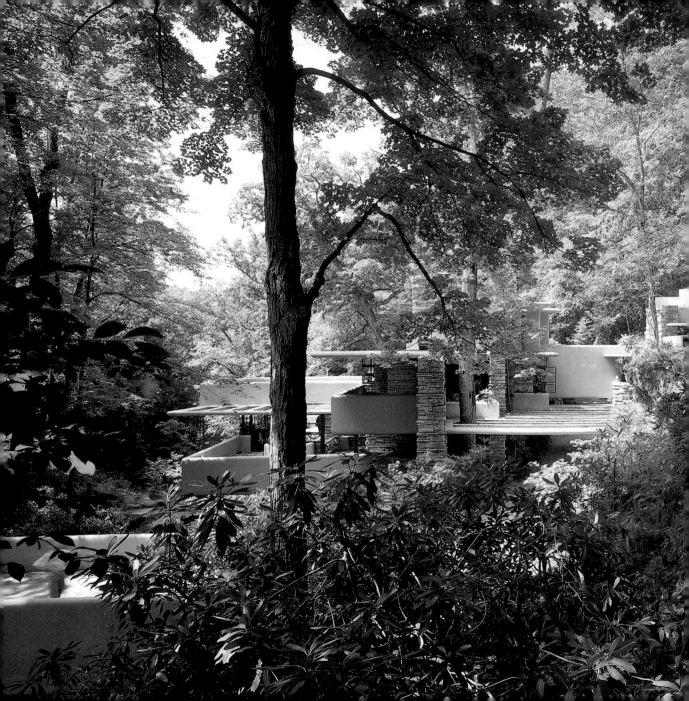

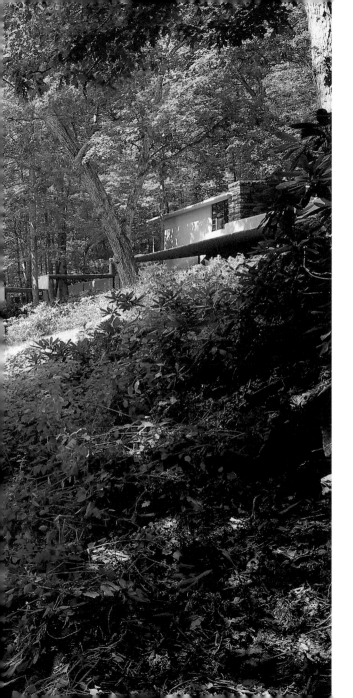

The pleasure
a palace or a temple
gives the eye is,
that an order and method
has been communicated to stones,
so that they speak and geometrize,
become tender or sublime
with expression.
**BEAUTY
IS THE
MOMENT
OF
TRANSITION,**
as if the form were just
ready to flow into
other forms.
—Emerson

Canopy joining main house to
guest house, East view
Previous pages: Canopy, South elevation

A

rchitecture already favors
the reflex, the natural easy attitude,
the occult symmetry of the grace
and rhythm affirming the ease, grace,
and naturalness of natural life.
—Frank Lloyd Wright, 1939

Stream with branch,
Western Pennsylvania

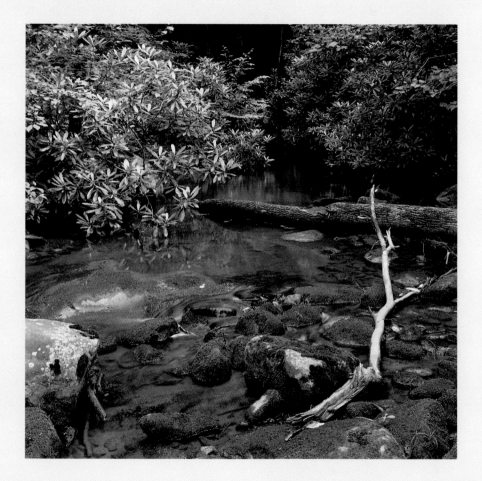

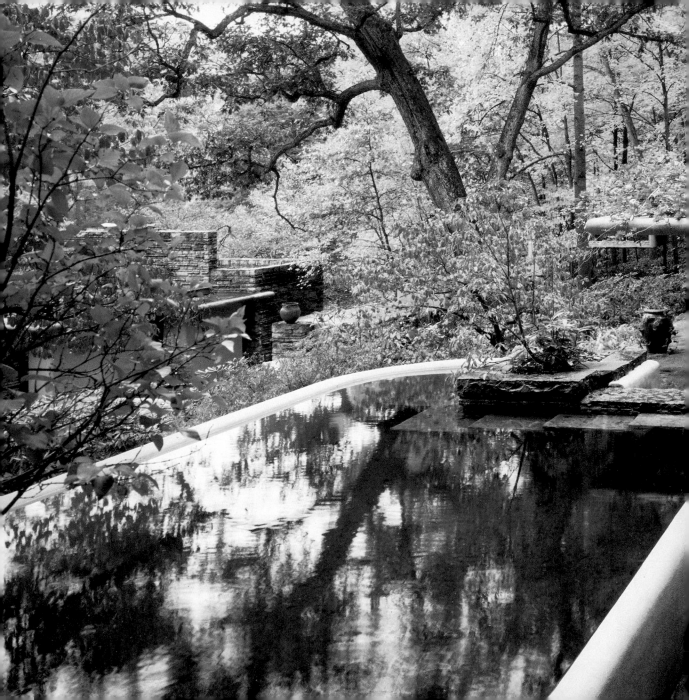

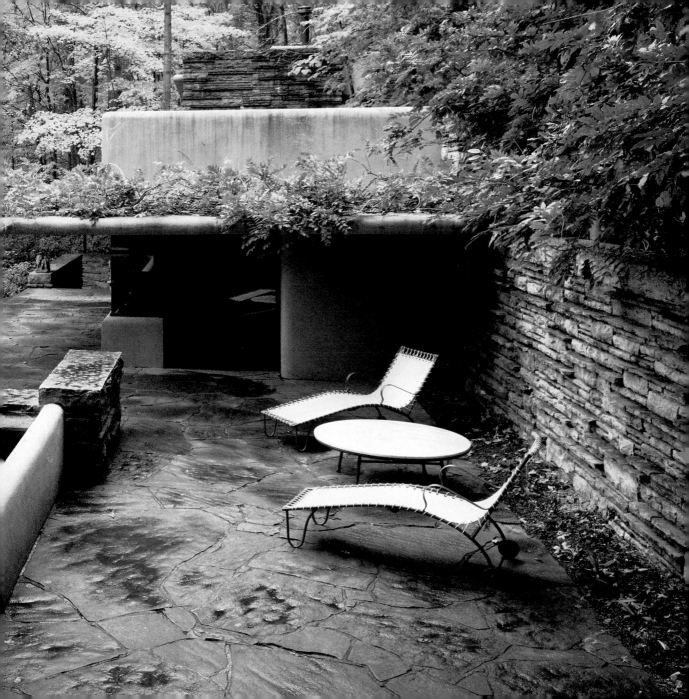

The snow falls on no two trees alike, but the forms

it assumes are as various as those of the

twigs and leaves which receive it.

They are, as it were, predetermined by

the genius of the tree.

So one divine spirit descends alike on all,

but bears a peculiar fruit in each.

The divinity subsides on all men,

as the snowflakes settle on the fields and ledges

and takes the form of the various clefts

and surfaces on which it lodges.

—Thoreau

Snow on hemlocks, Western Pennsylvania
Previous pages: Guest house pool
looking toward canopy, Fall

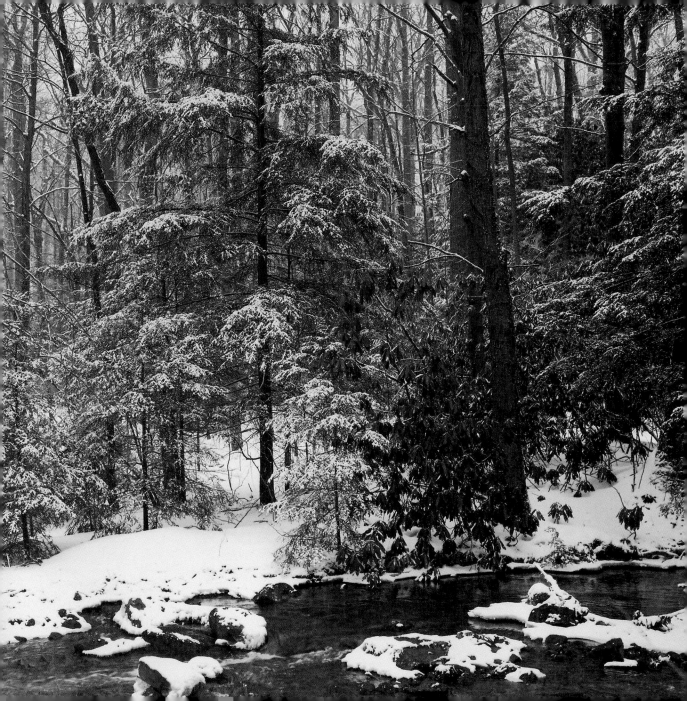

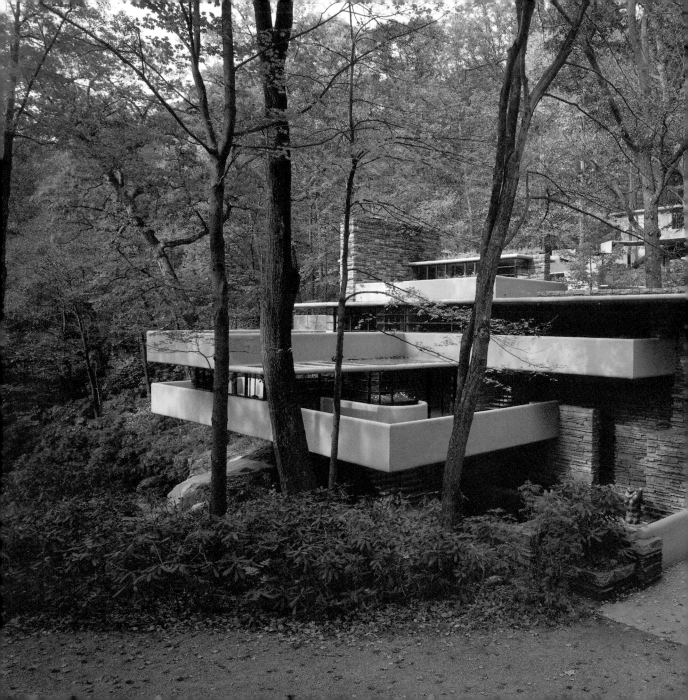

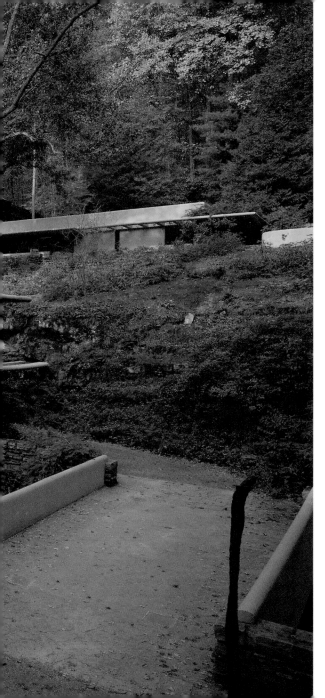

What architectural beauty I see

I know has grown from within outward—

out of the necessities and character

of the indweller and whatever additional

beauty of this kind is destined to be

produced will be preceded by a like

unconscious beauty of life.

—Thoreau

Southeast elevation, Fall

W

eather is omnipresent and buildings must be left out in the rain. Shelter is dedicated to these elements. So much so that almost all other features of design tend to lead by one another to this important feature, shelter, and its component shade.... By shade, charm has been added to character; style to comfort; significance to form.

—Frank Lloyd Wright, 1957

Canopy
Following pages: Main house living room
with polished sandstone floor, Wright-designed
built-in furniture, and indirect lighting

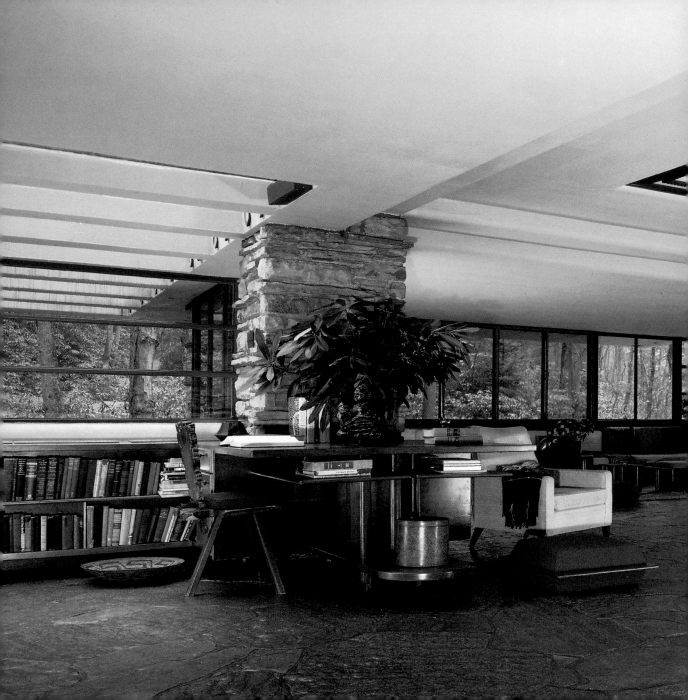

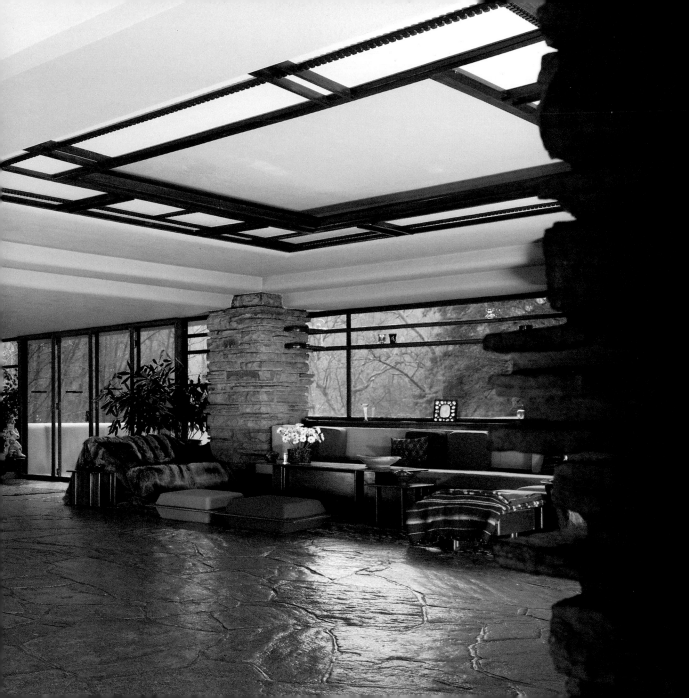

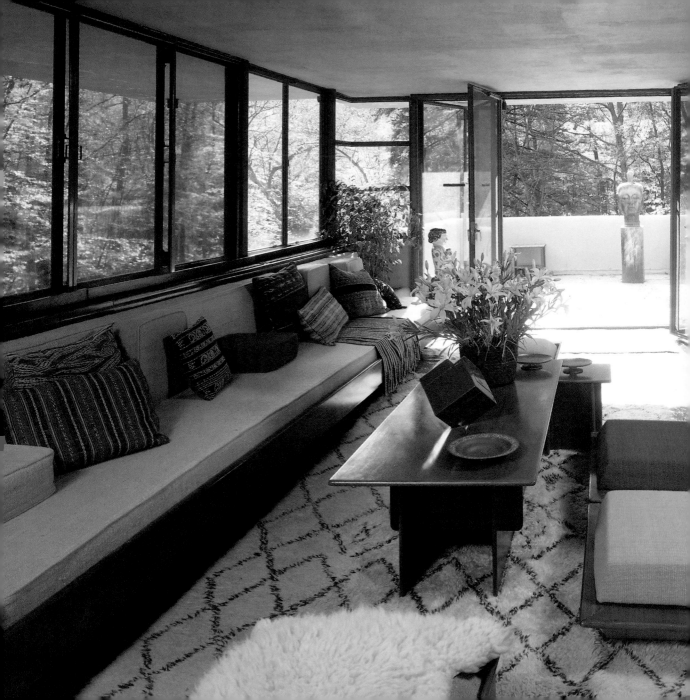

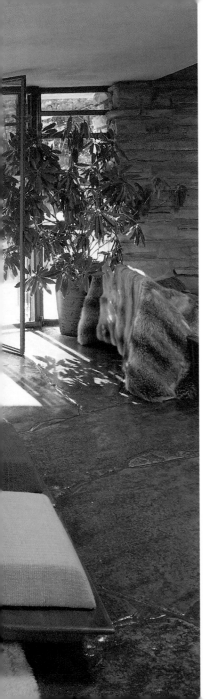

WINDOWS

The windows at Fallingwater are framed
by steel sashes. Instead of using large uninterrupted
sheets of glass and thereby treating the material
as if it were invisible, Wright chose to emphasize both
the physical presence of the glass and its function
as a sheltering protective membrane by framing it.
From within the building the windows act as
decorative screens that change
with the seasons.

Southern end of living room
with view to West terrace

LIVING SPACE

Nearly half of Fallingwater is terrace or exterior space. Each of the four bedrooms has its own terrace, and there are two terraces off the living room. Frequently used for sunbathing, reading, and dining, they brought nature into the routines of everyday life at Fallingwater.

Edgar Kaufmann, jr.'s sleeping alcove
Following pages: South elevation at twilight

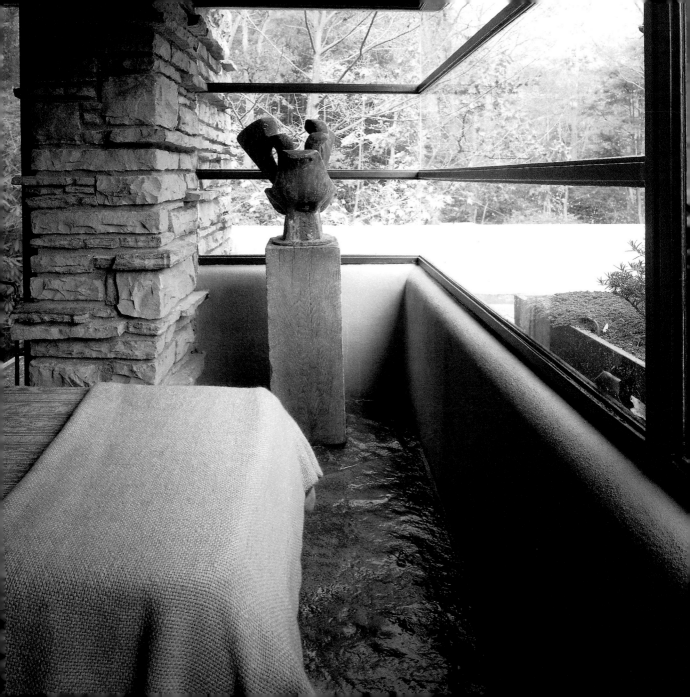

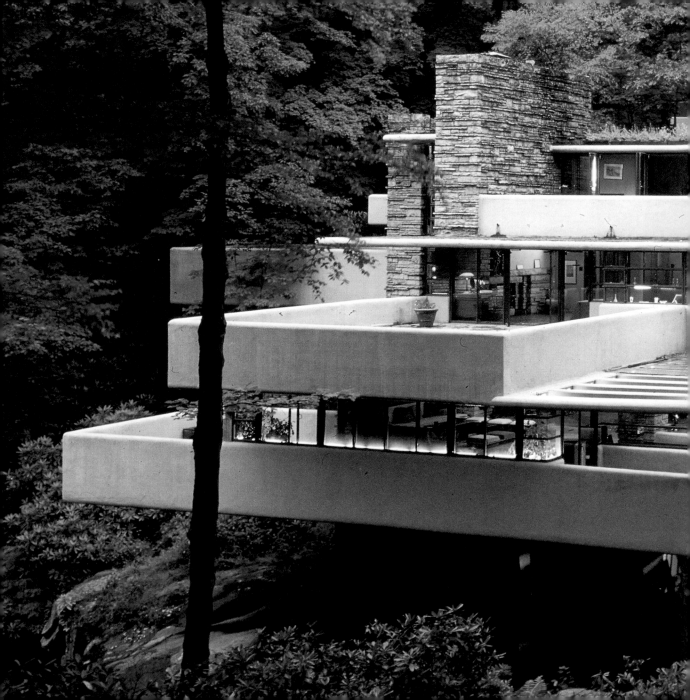

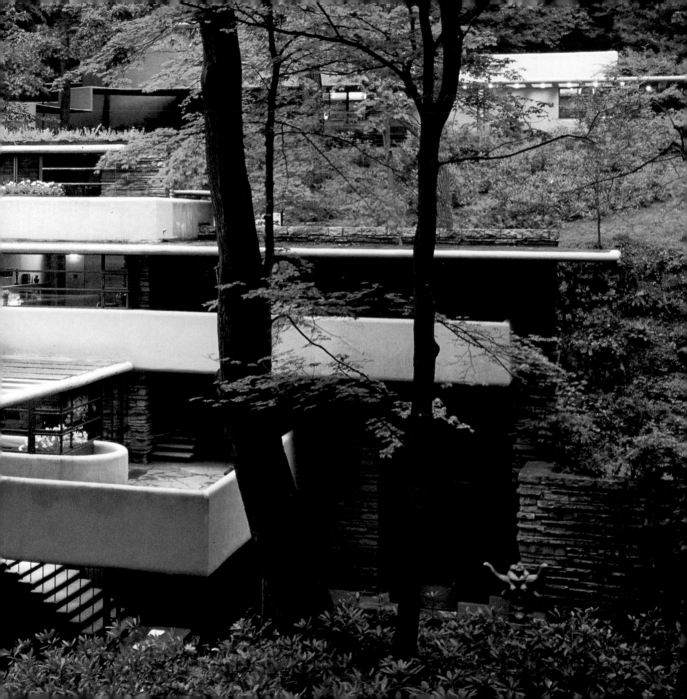

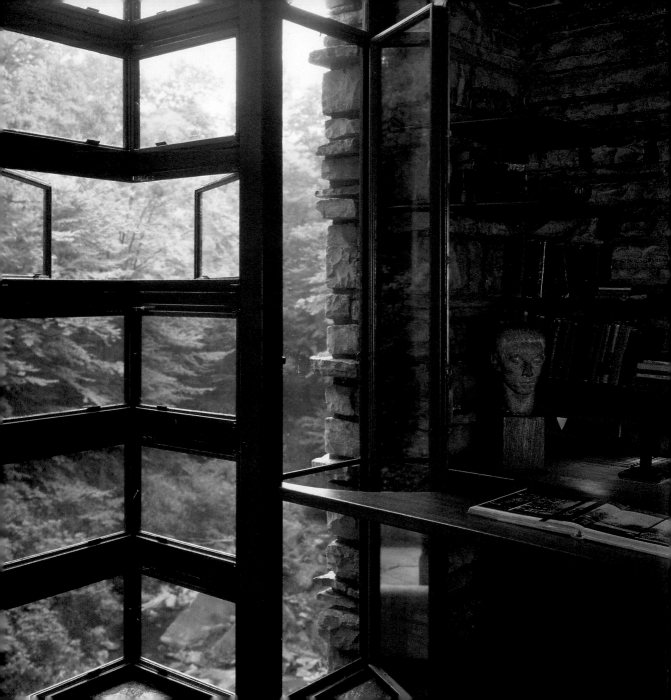

The corner-window is indicative

of an idea conceived,

early in my work, that the box is a

Fascist symbol, and the architecture of freedom

and democracy needed something basically better

than the box. So I started to destroy

the box as a building. Well, the corner-window

came in as all the comprehension that was ever given

to that act of destruction of the box.

The light now came in where it had never

come in before and vision went out.

You had screens for walls instead of box

walls—here the walls vanished as walls,

the box vanished as a box.

—Frank Lloyd Wright, 1953

Edgar Kaufmann's dressing
room with desk and corner window
Following pages: Living room,
fireplace, and buffet

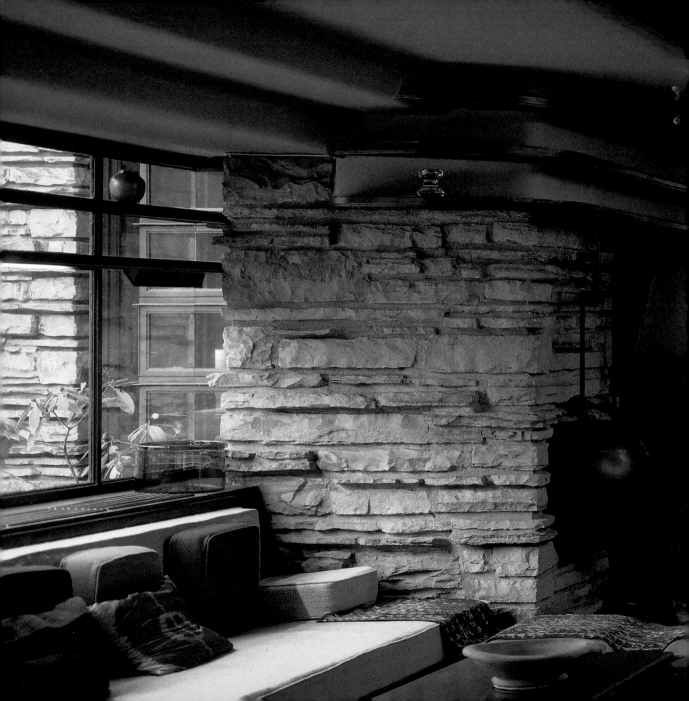

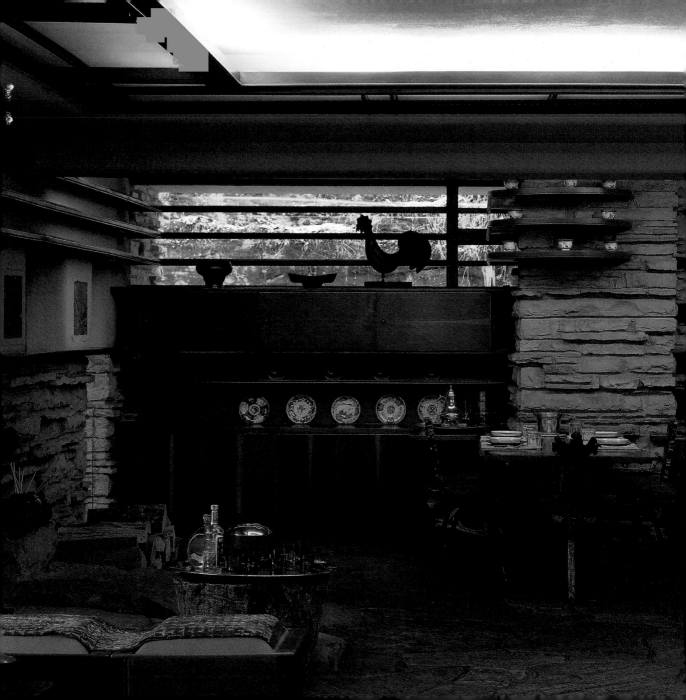

THE FURNISHINGS

at Fallingwater were designed by Wright specifically for the house. The built-in seating is cantilevered from the wall in a manner that echoes the way in which the house is cantilevered over the waterfall. Likewise, these benches hug the perimeter of the room and appear to grow from the house itself, just as the house seems to grow from its site.

Living room, seating area

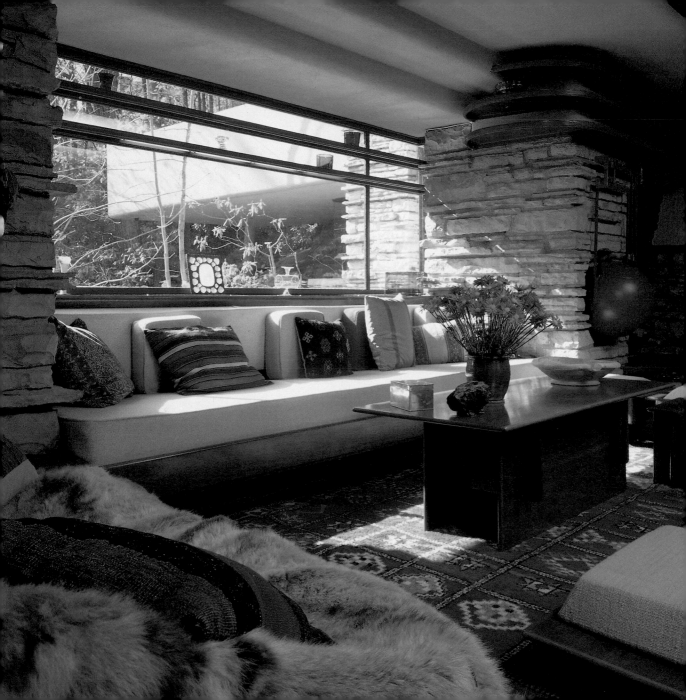

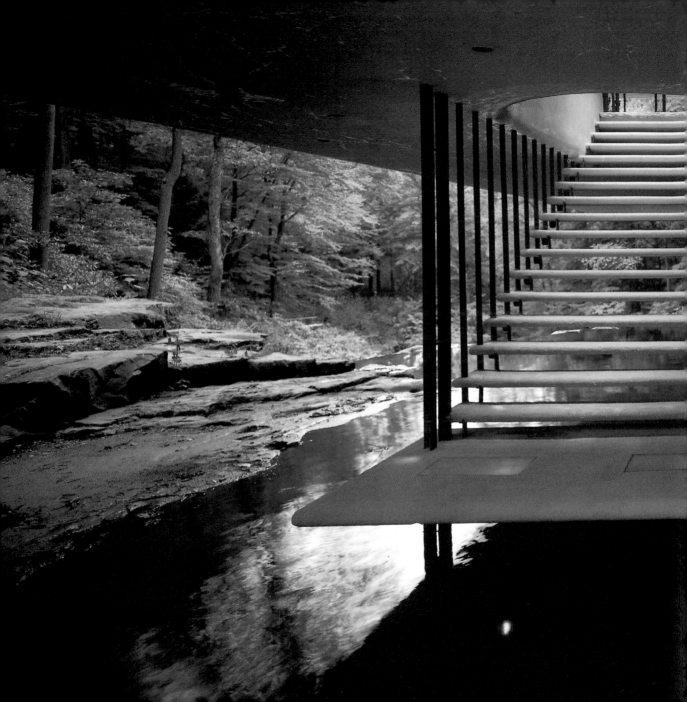

Simplicity is a clean, direct
expression of that
essential quality of the thing
which is in the nature
of the thing itself.
**The innate or organic
pattern**
of the form of anything
is that form which is
thus truly simple.
—Frank Lloyd Wright, 1954

Stairs from living room to stream

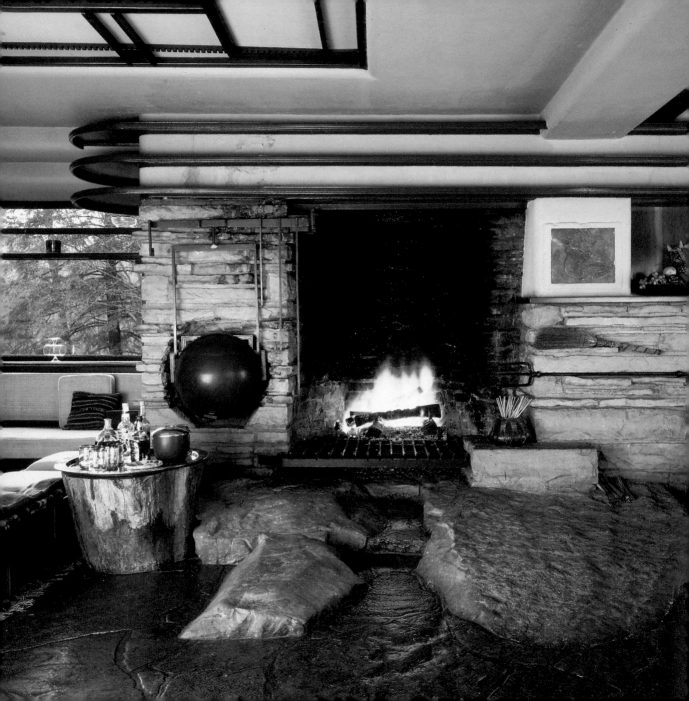

THE FIREPLACE

is perhaps the single element of Wright's interiors that is the most telling of his approach to domestic architecture and his roots in the romantic period of the nineteenth century. For Wright, the fireplace evoked primordial associations: the family gathered around the hearth, the safety of the home, and the sense of emotional and physical comfort. At Fallingwater the fireplace is the focal point of the living room. Anchored on a massive natural sandstone outcropping that also serves as the hearth, it has an opening that is nearly six feet high. The great cast-iron kettle was designed to swing out over the fire and was used for mulling wine on cold winter days.

Living room, fireplace

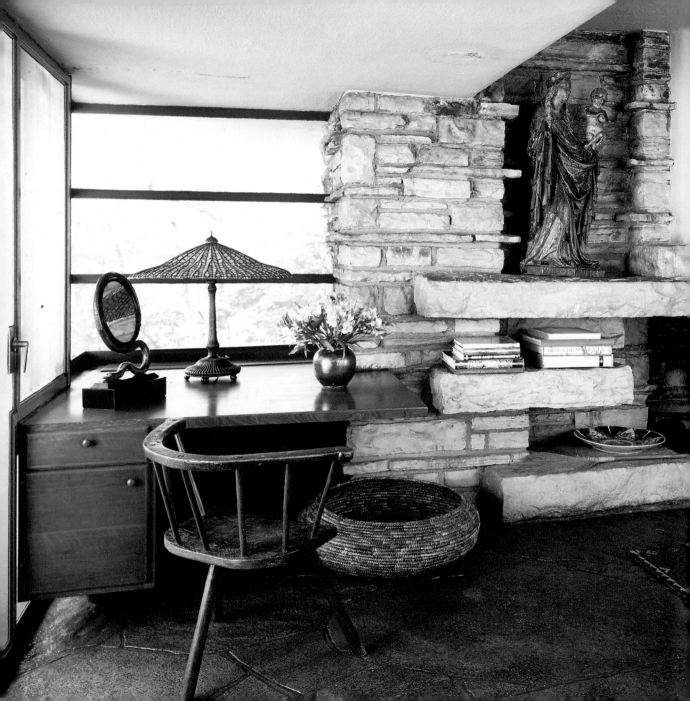

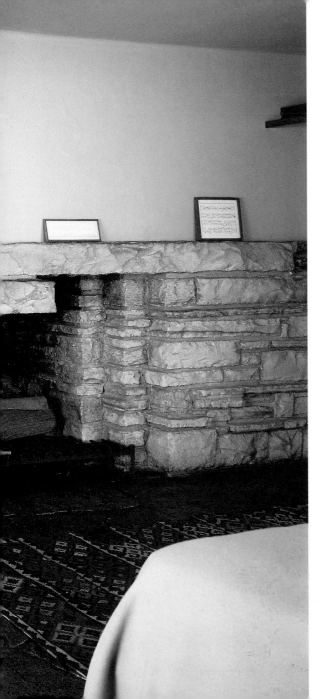

Possibly the most beautifully
detailed fireplace is found in
the master bedroom.
Of interest are its three
large stones that play upon
the theme of ledge
and cantilever.

Master bedroom with desk and fireplace

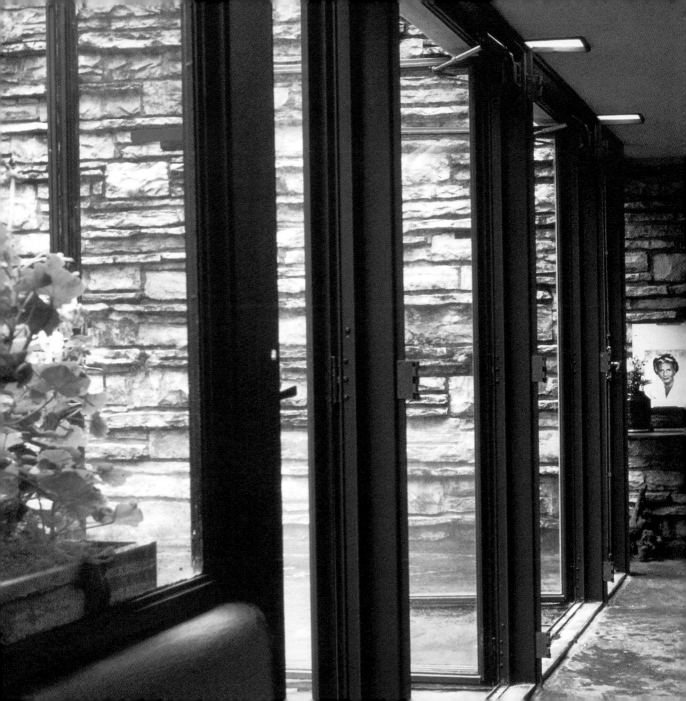

T

here is a similarity of vision
in creation between Music and Architecture.
Only the nature of the materials differ.
—Frank Lloyd Wright, 1943

Third floor gallery doors
Following pages: Edgar Kaufmann, jr.'s study

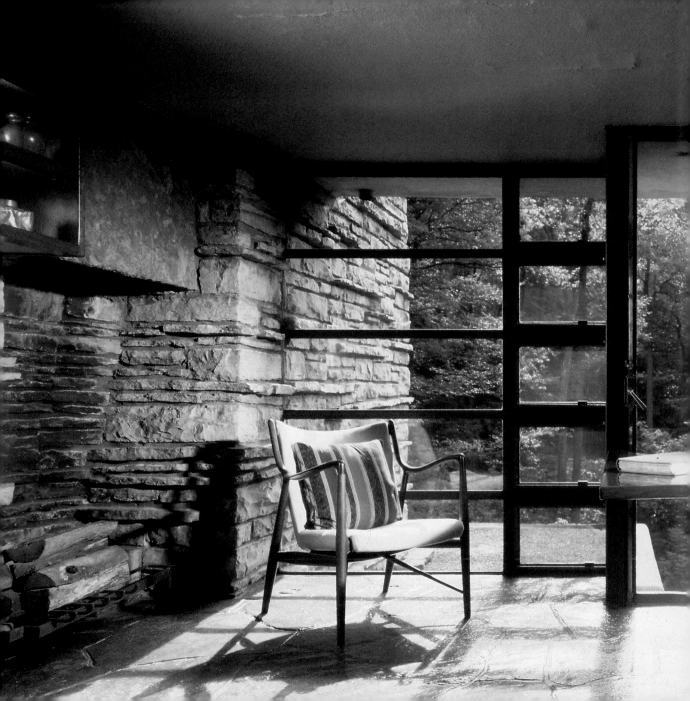

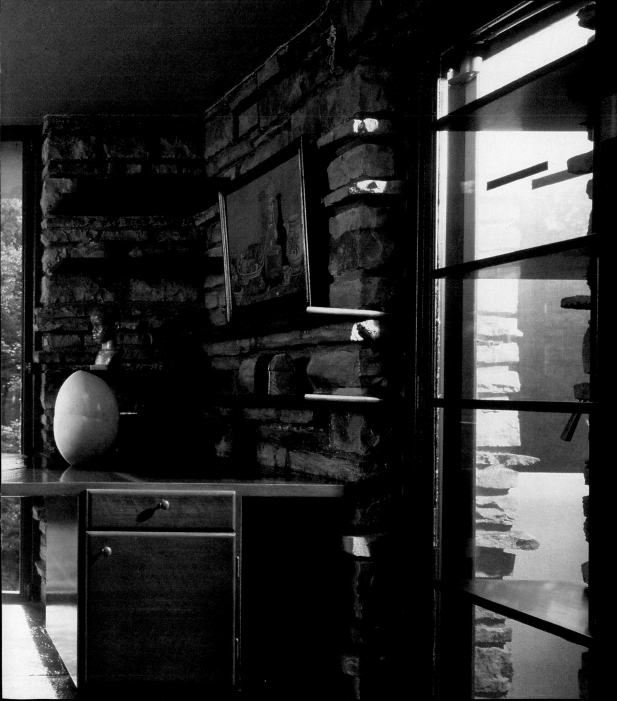

Who are you,

indeed, who would talk

or sing to America?

Have you studied out the land, its idioms,

and men? Have you learned the physiology,

phrenology, politics, geography, pride,

freedom, friendship of the land?

— Whitman

River view, Western Pennsylvania
Right: Dogwood, Western Pennsylvania

SELECT READING LIST

Bolon, Carol R., Robert S. Nelson, and Linda Seidel, eds. *The Nature of Frank Lloyd Wright.* Chicago: The University of Chicago Press, 1988.

Brooks, H. Allen. *Writings on Wright.* Cambridge, Massachusetts: The MIT Press, 1988.

Emerson, Ralph Waldo. *The Writings of Ralph Waldo Emerson.* Brooks Atkinson, ed. New York: Random House, 1940.

Hearn, M. F., ed. *The Architectural Theory of Viollet-le-Duc: Readings and Commentary.* Cambridge, Massachusetts: The MIT Press, 1990.

Hildebrand, Grant. *The Wright Space: Pattern and Meaning in Frank Lloyd Wright's Houses.* Seattle: University of Washington Press, 1991.

Hoffmann, Donald. *Fallingwater: The House and Its History.* Second, revised edition. New York: Dover Publications, 1993.

_____. *Understanding Frank Lloyd Wright's Architecture.* New York: Dover Publications, 1995.

Kaufmann, Edgar, jr. *Fallingwater: A Frank Lloyd Wright Country House.* New York: Abbeville Press Publishers, 1986.

Kouwenhoven, John, ed. *Leaves of Grass and Selected Prose by Walt Whitman.* Modern Library Edition, 1921. New York: Random House, 1950.

McCarter, Robert. *Architecture in Detail: Fallingwater.* London: Phaidon Press, 1994.

Pfeiffer, Bruce Brooks, ed. *Frank Lloyd Wright: Collected Writings.* Volumes 1–5. New York: Rizzoli International Publications, Inc., 1992.

Rothwell, Robert L., ed. *Henry David Thoreau: An American Landscape.* New York: Marlowe and Company, 1991.

Ruskin, John. *The Seven Lamps of Architecture.* New York: Dover Publications, 1989. (First published in 1880.)

Twombley, Robert. *Frank Lloyd Wright: His Life and His Architecture.* New York: Wiley, 1979.

NOTES

pages

19: Rothwell, Robert, ed. *Henry David Thoreau: An American Landscape* (New York: Marlowe and Company, 1991).

20: Ruskin, John. "The Lamp of Beauty," *The Seven Lamps of Architecture* (New York: Dover Publications, 1989 [First published in 1880]).

23: Pfeiffer, Bruce Brooks, ed. *Frank Lloyd Wright: Collected Writings*, Volumes 1–5 (New York: Rizzoli International Publications, Inc., 1992), Vol. 5.

25: Pfeiffer. Vol. 2.

26: Emerson, Ralph Waldo. "Nature," *Essays and English Traits*, Harvard Classics, Charles W. Elliot, L.L.D., ed. (New York: P. F. Collier and Son, 1909).

29: Pfeiffer. Vol. 3.

34: Kaufmann, Edgar, jr. From a talk given to the Fallingwater guides. May 31, 1974.

37: Hoffmann, Donald. *Fallingwater: The House and Its History*, Second, revised edition (New York: Dover Publications, 1993).

41: Emerson. "Beauty."

42: Pfeiffer. Vol. 3.

46: Rothwell.

49: Wright, Frank Lloyd. *Architecture Forum*, January 1938.

51: Pfeiffer. Vol. 5.

61: Wright, Frank Lloyd. From an interview with Hugh Downs (Copyright: NBC), May 17, 1953.

67: Pfeiffer. Vol. 5.

73: Wright, Frank Lloyd. *An Autobiography* (New York: Duell, Sloan and Pearce, 1943).

76: Kouwenhoven, John, ed. *Leaves of Grass and Selected Prose by Walt Whitman*, Modern Library Edition, 1921 (New York: Random House, 1950).

Back cover: Wright. From an interview with Hugh Downs.

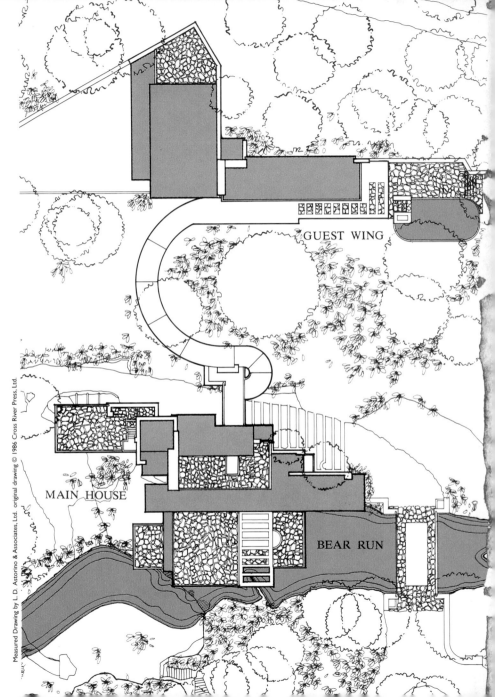

PHOTO CREDITS

Site plan (detail), showing main house over the falls of Bear Run, guest wing, and canopy joining the two buildings

GUEST WING

MAIN HOUSE

BEAR RUN

Measured Drawing by L.D. Astorino & Associates, Ltd. original drawing © 1986 Cross River Press, Ltd.

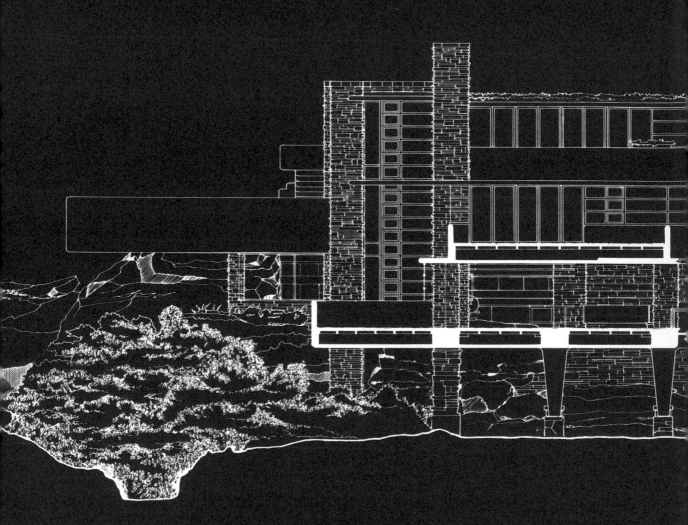